The Author's Photograph Collection
Second Edition
By Steve Presley

Here are some pictures of me: Most are about Peru, Indiana and at the Oak Haven Stables on State Hwy 31 seven miles southwest of town. The big black and white horse is my horse, Marshal Dillon. He is Belgian/Clydesdale draft horse mixed with Tennessee walking horse. I have his mother's blood line back to the year 1125. He is related to the Pusher C.G., Seabiscuit, and Trigger Jr. The cars are a 1988 Chevrolet S-10, a 2003 Buick Century, and a 2000 Jaguar Type S, and a 1986 Corvette fastback.

Pictures of me:

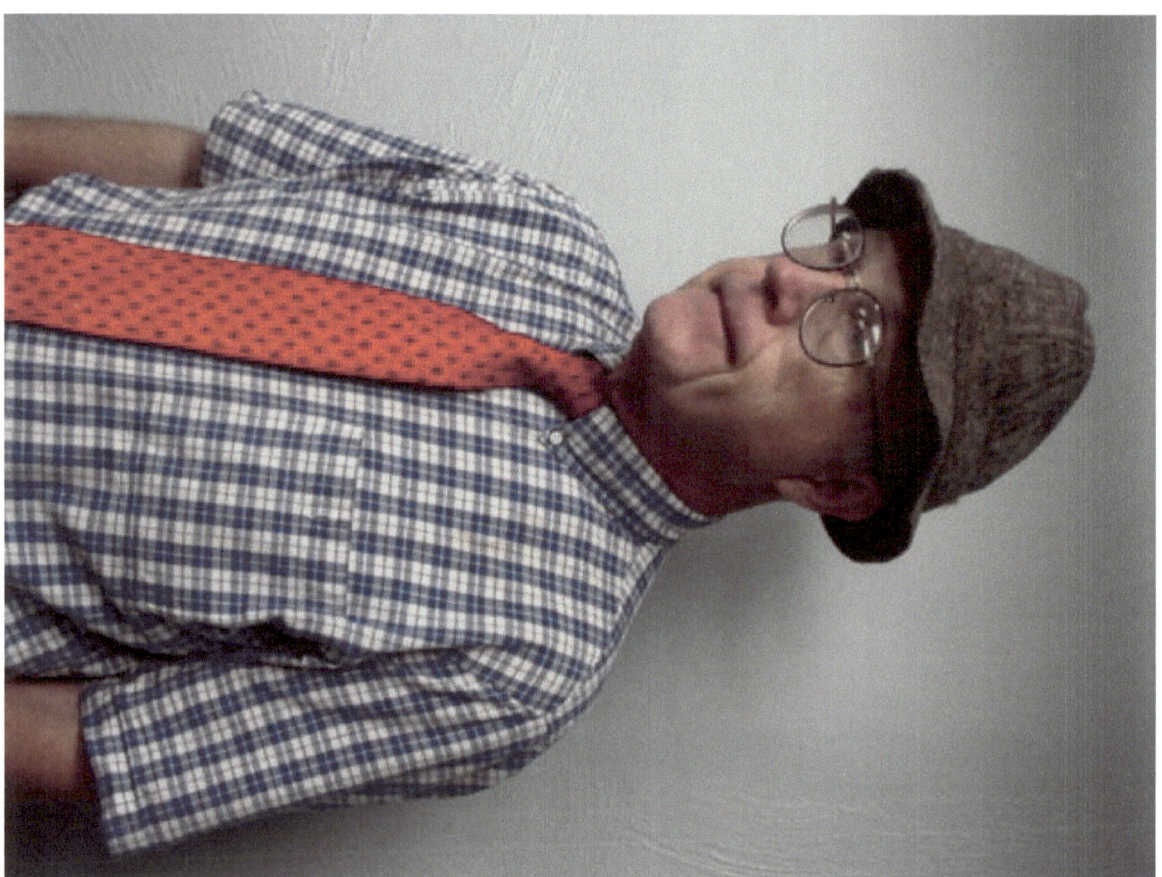

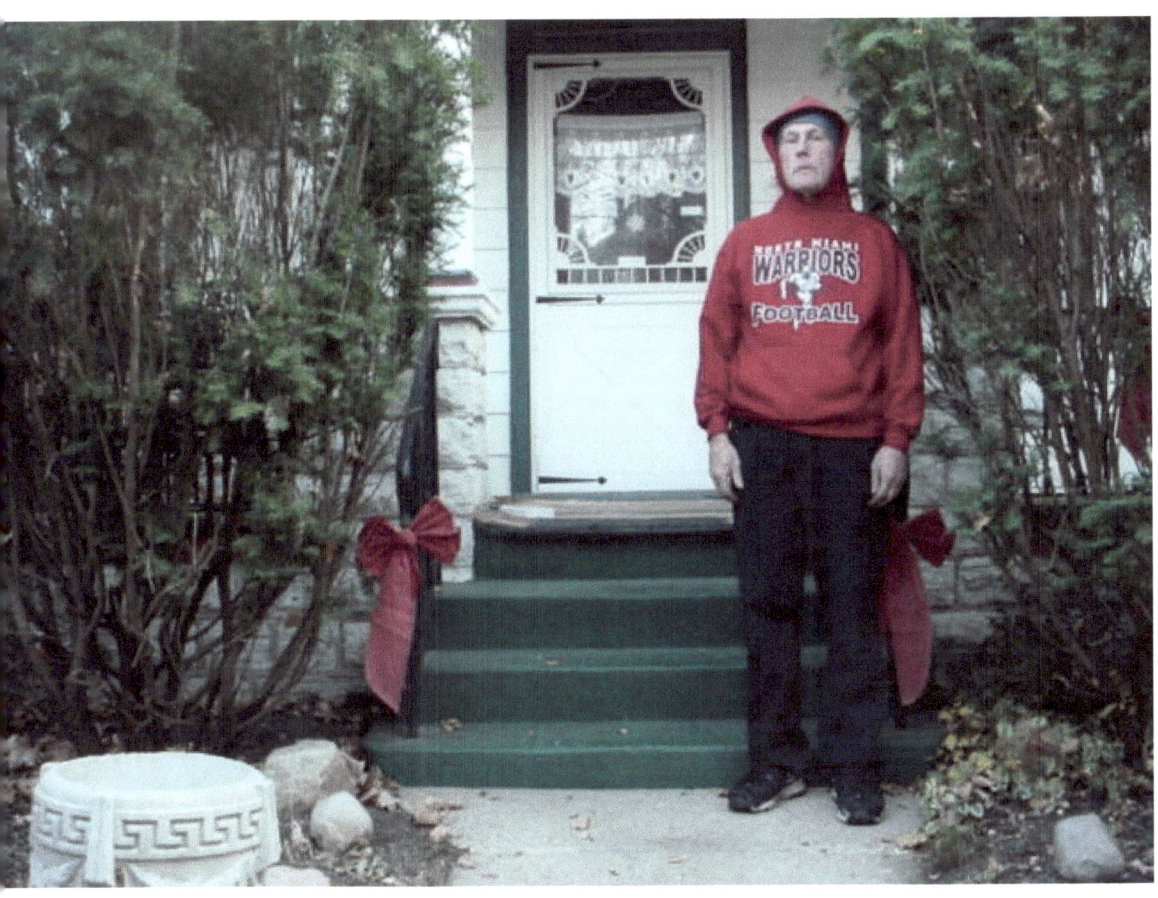

Pictures of my home:

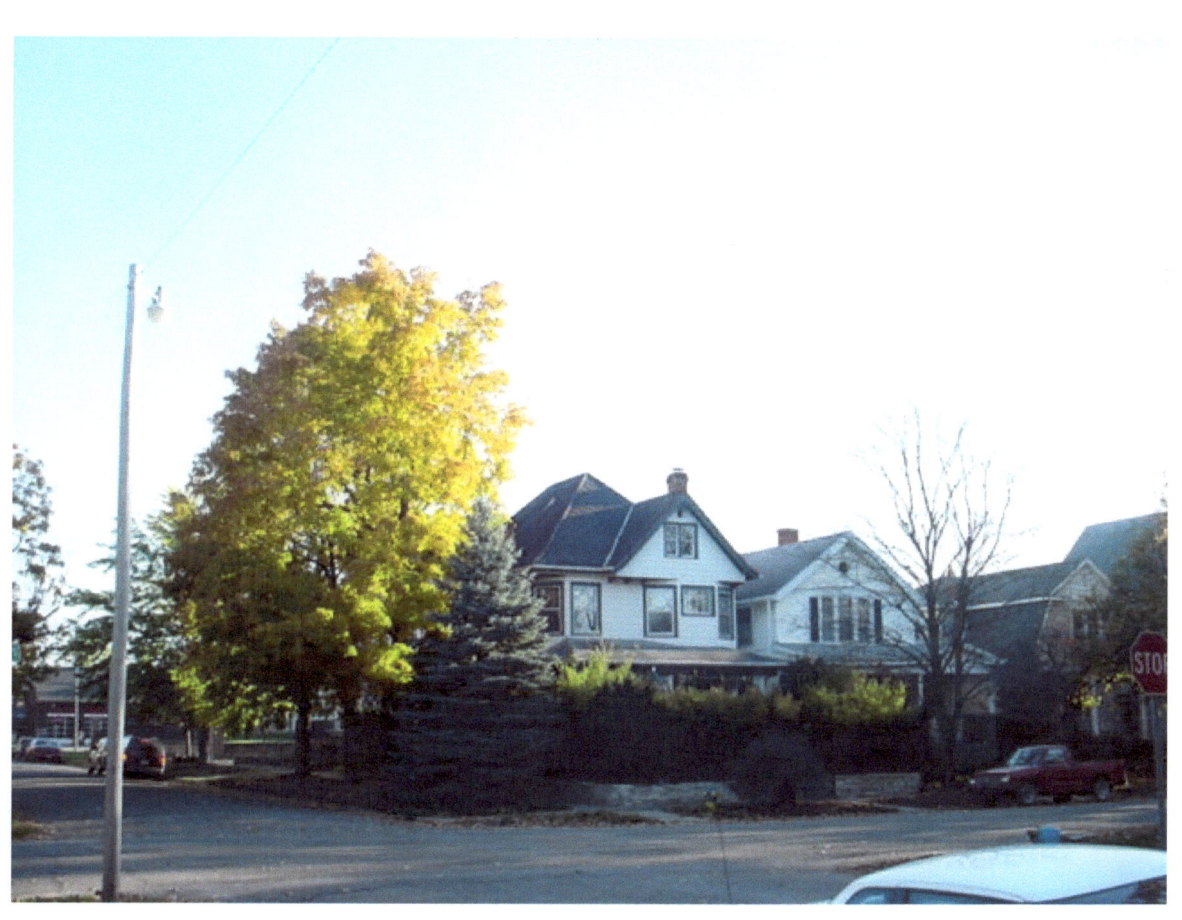

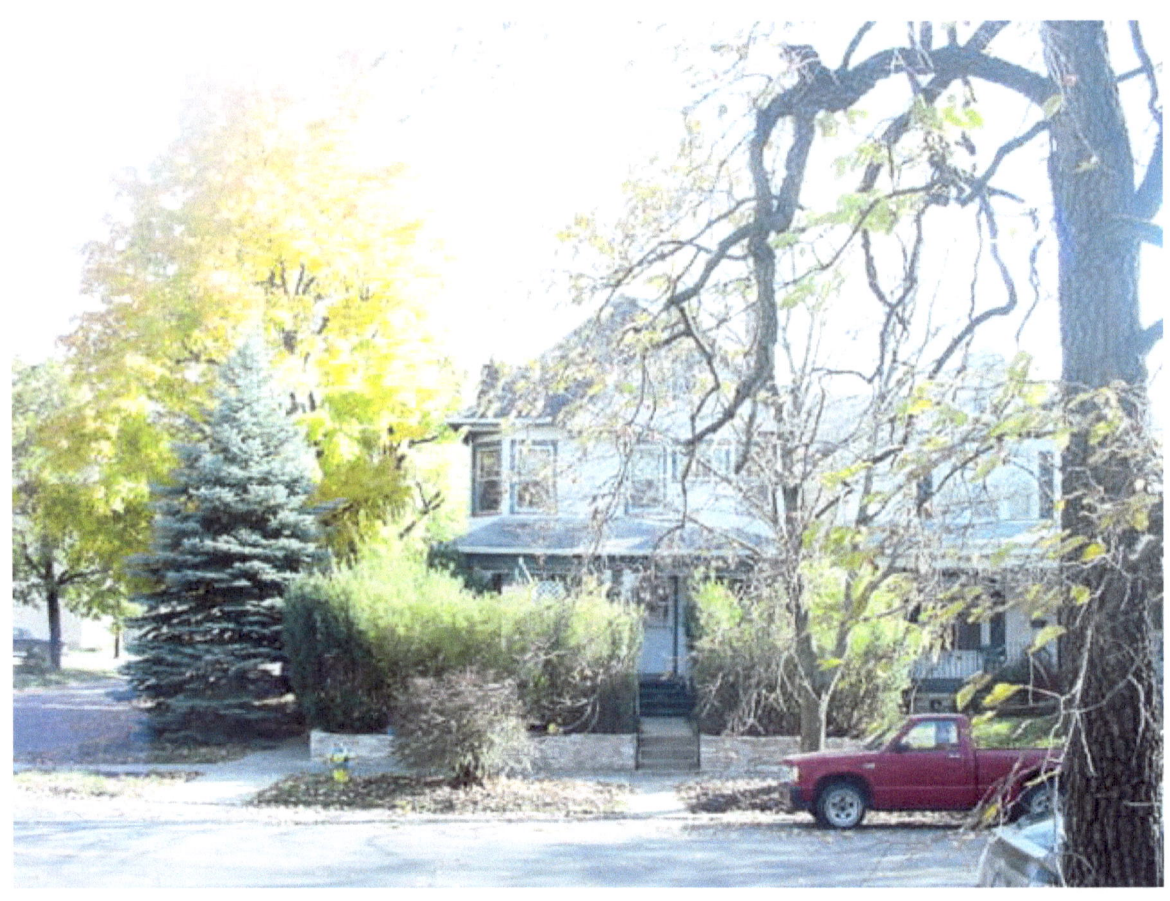

Pictures of me and my horse, Marshal Dillon:

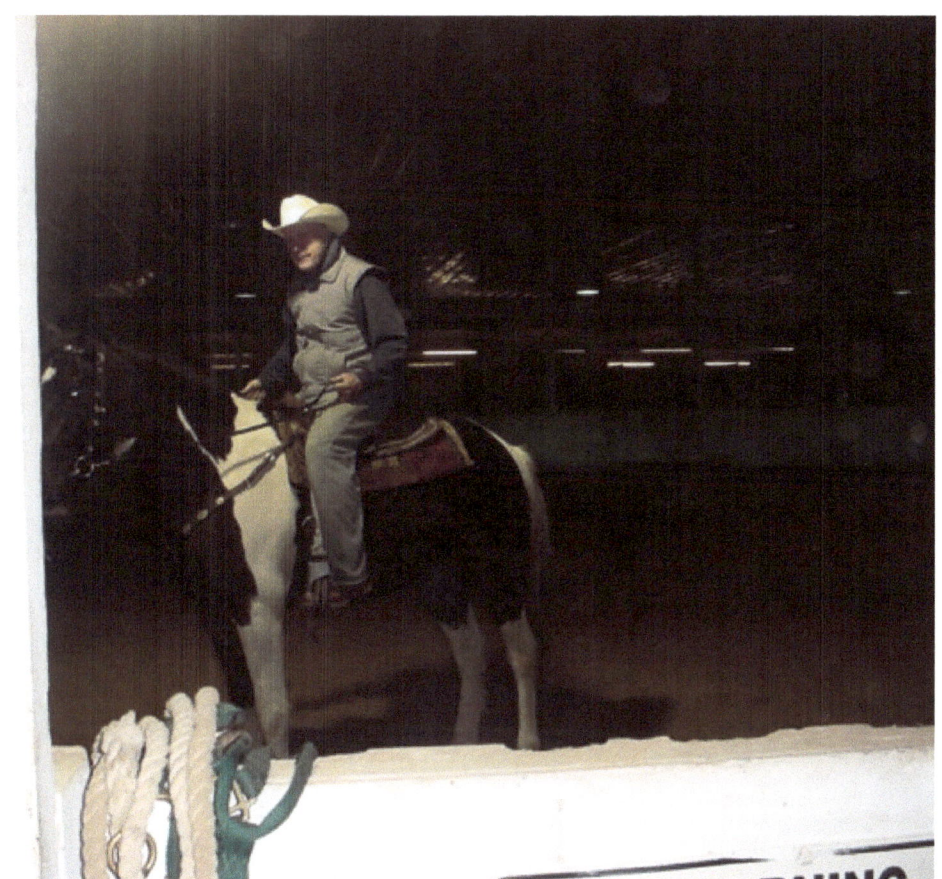

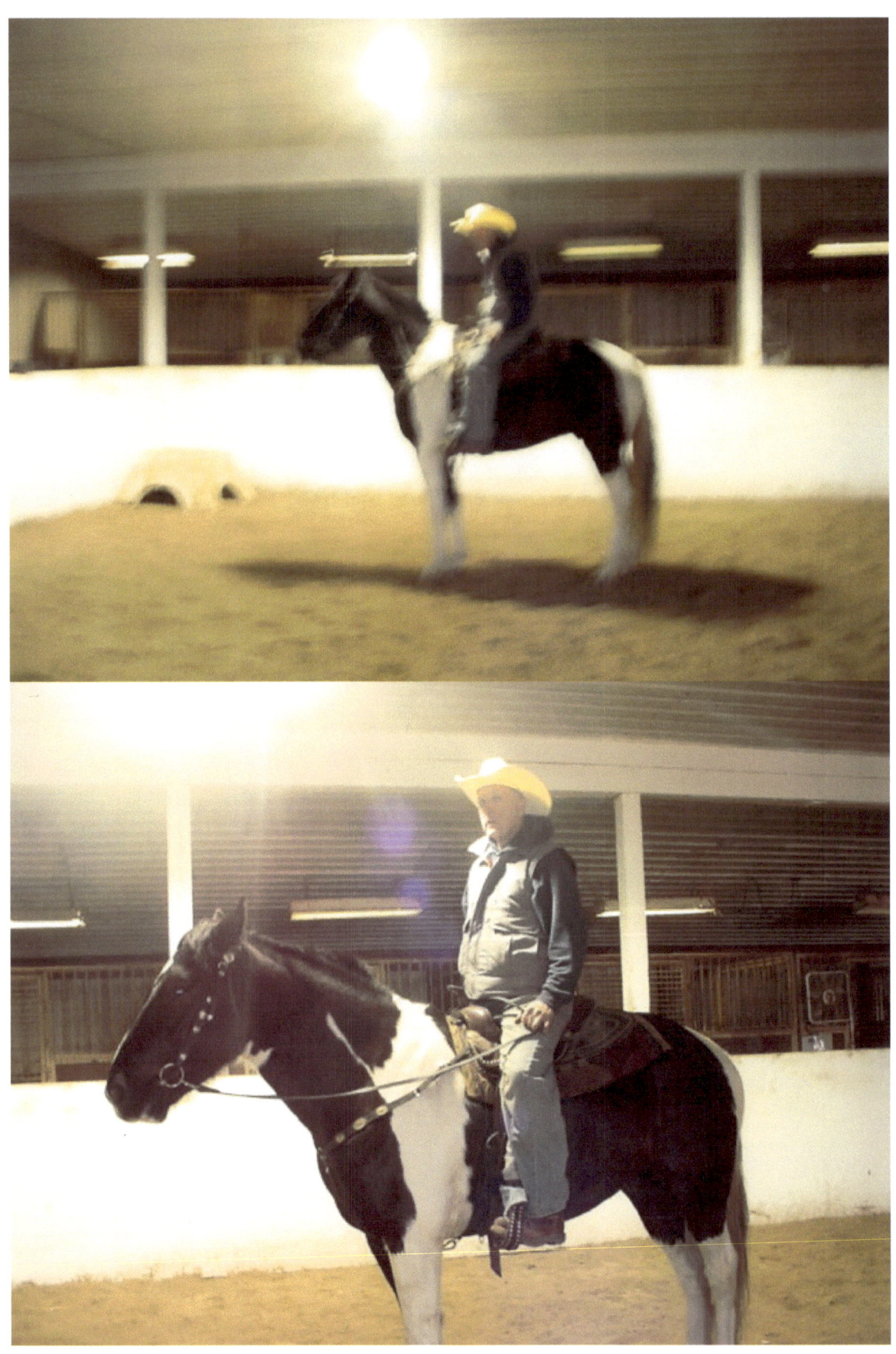

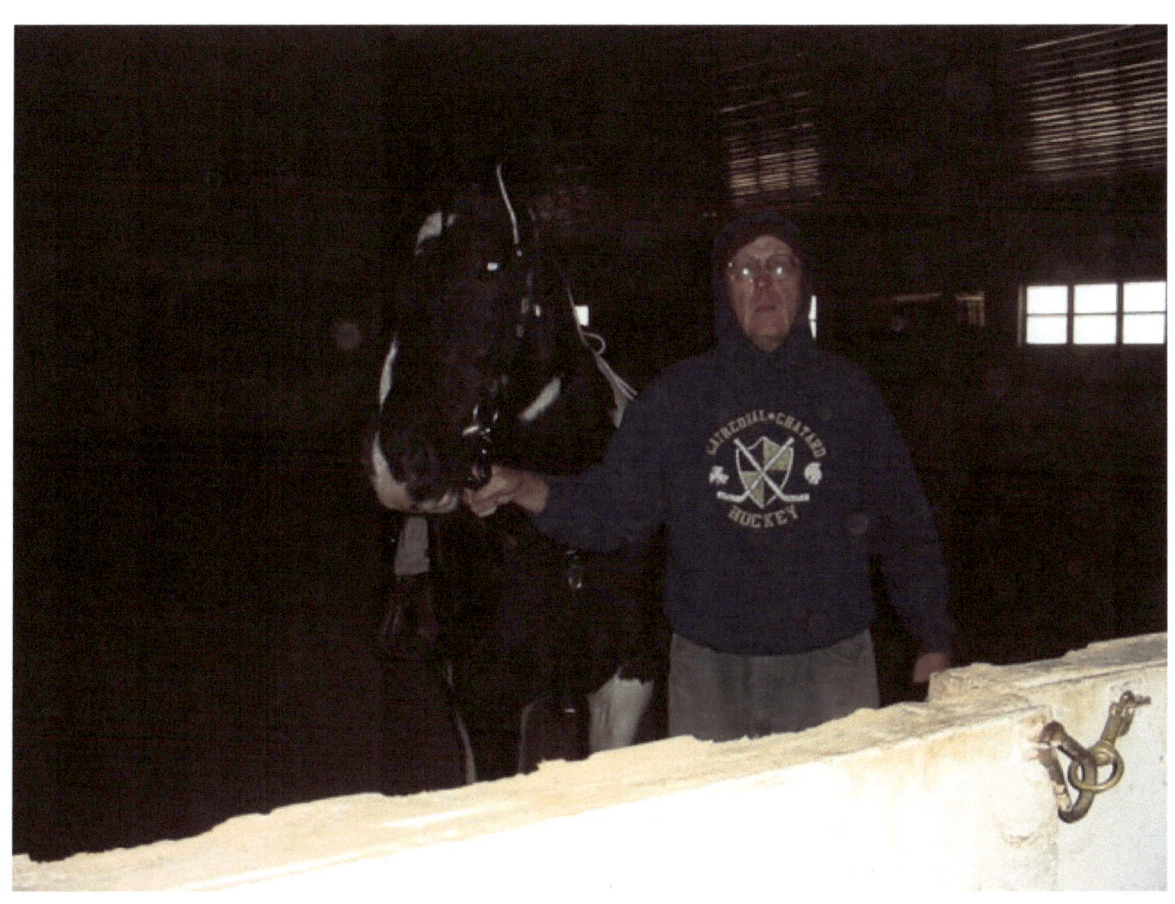

Pictures of me and my cars:

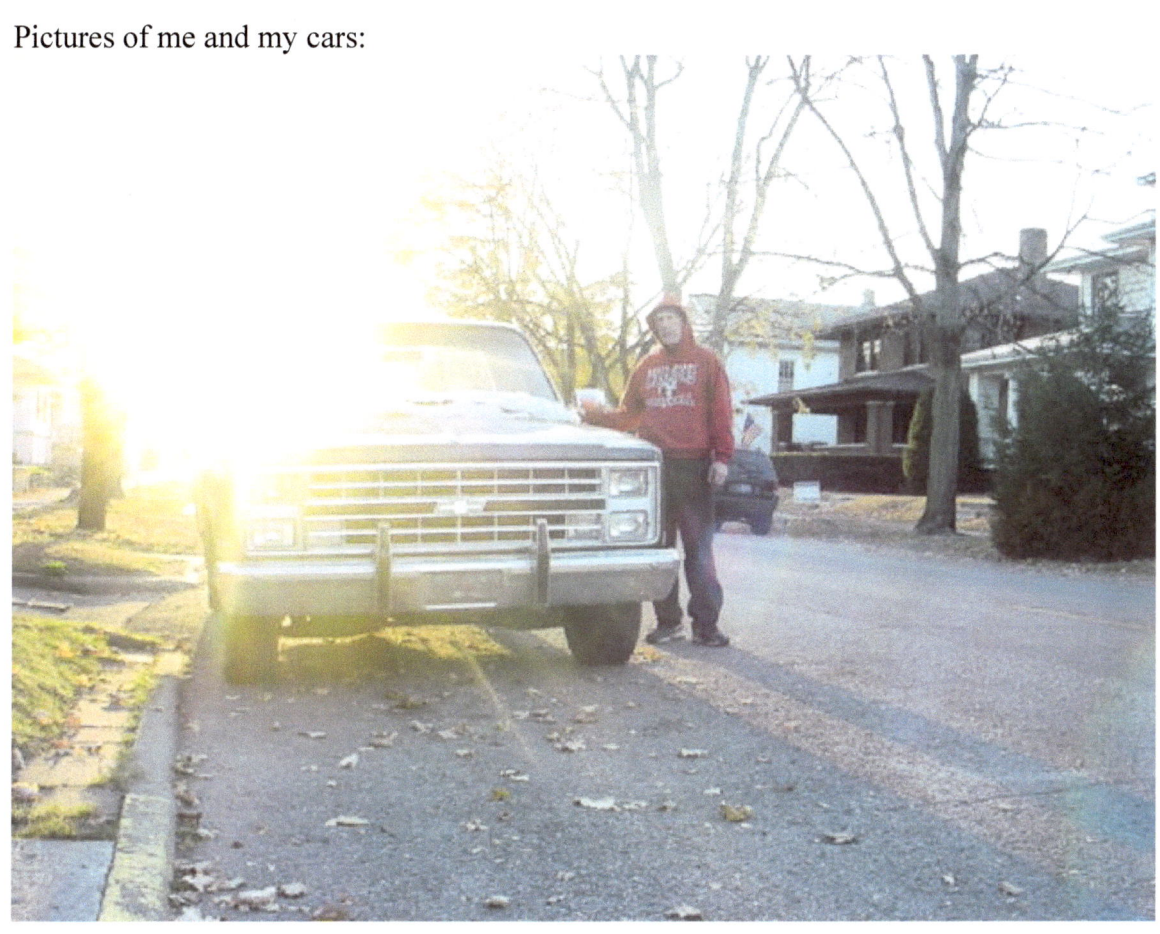

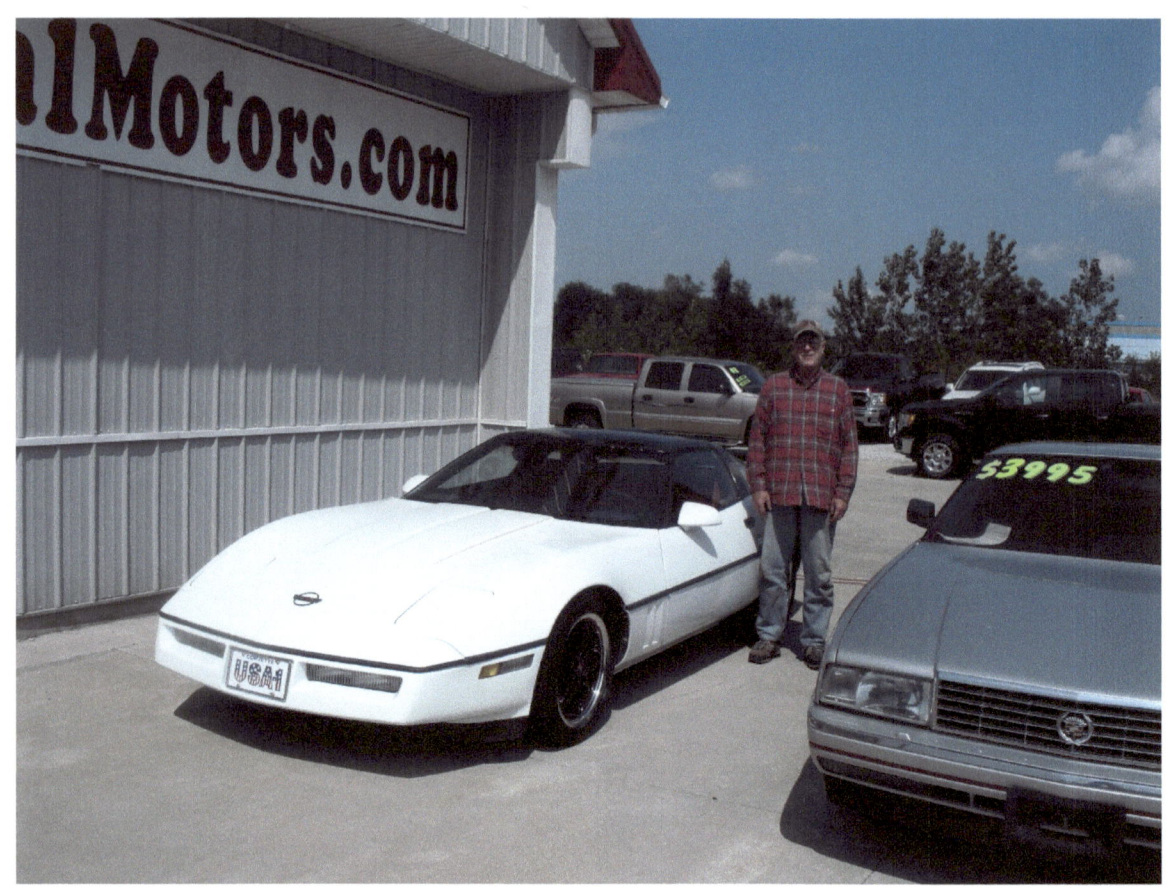

Pictures of me hunting:

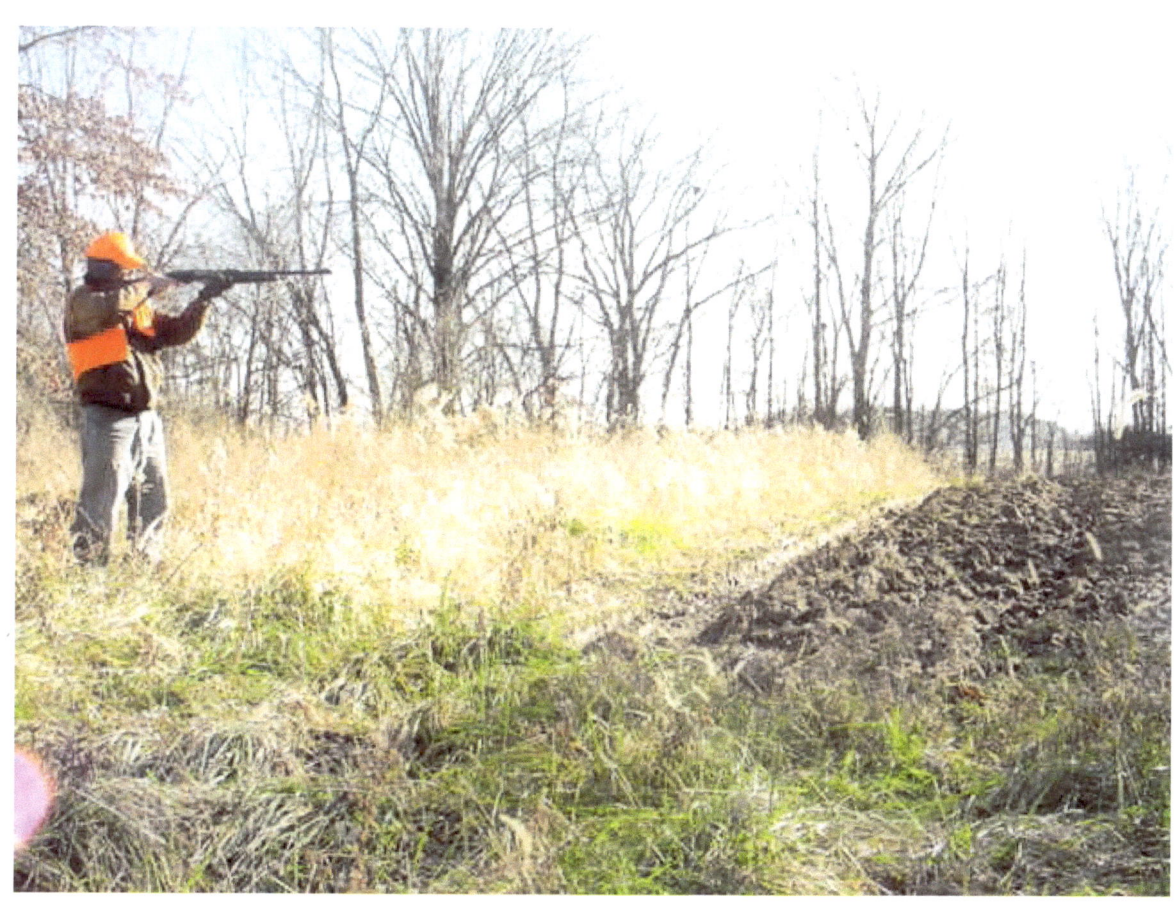

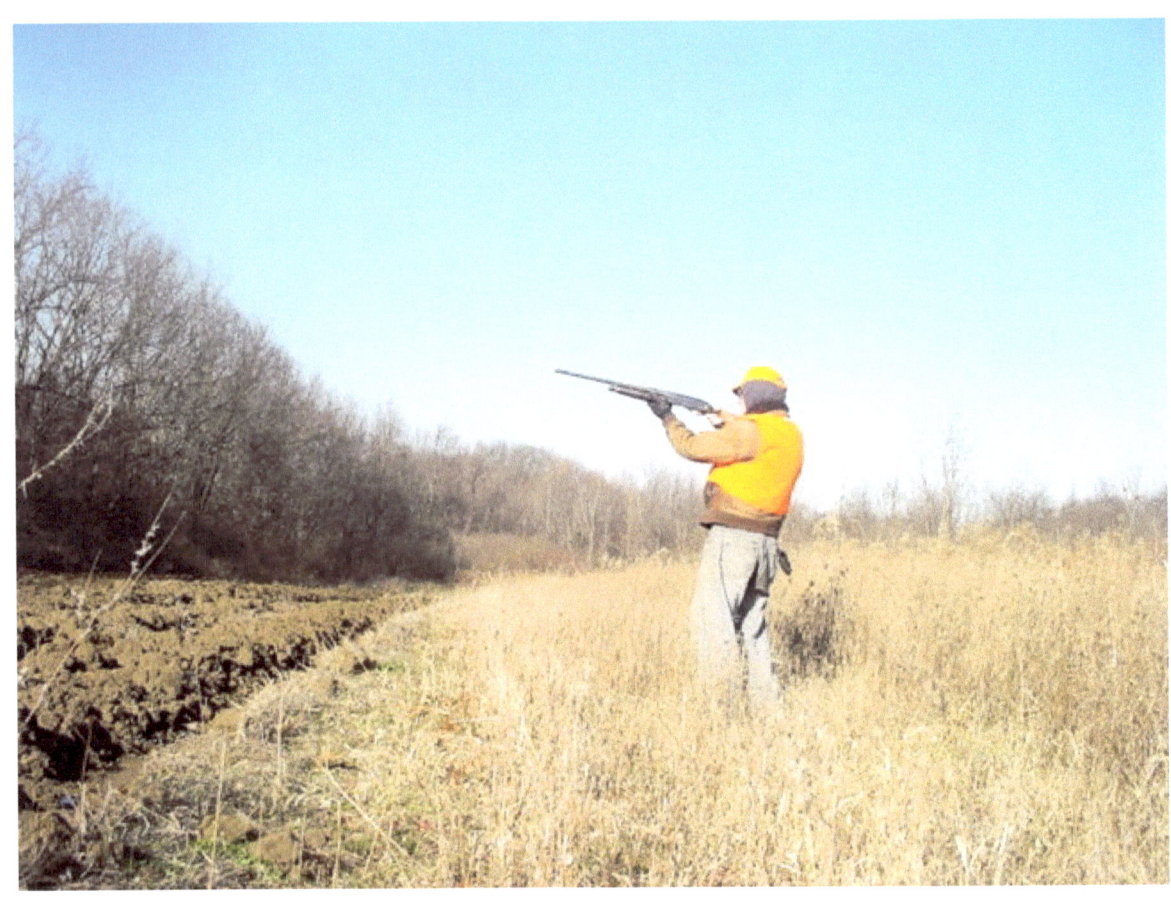

Pictures of me fishing:

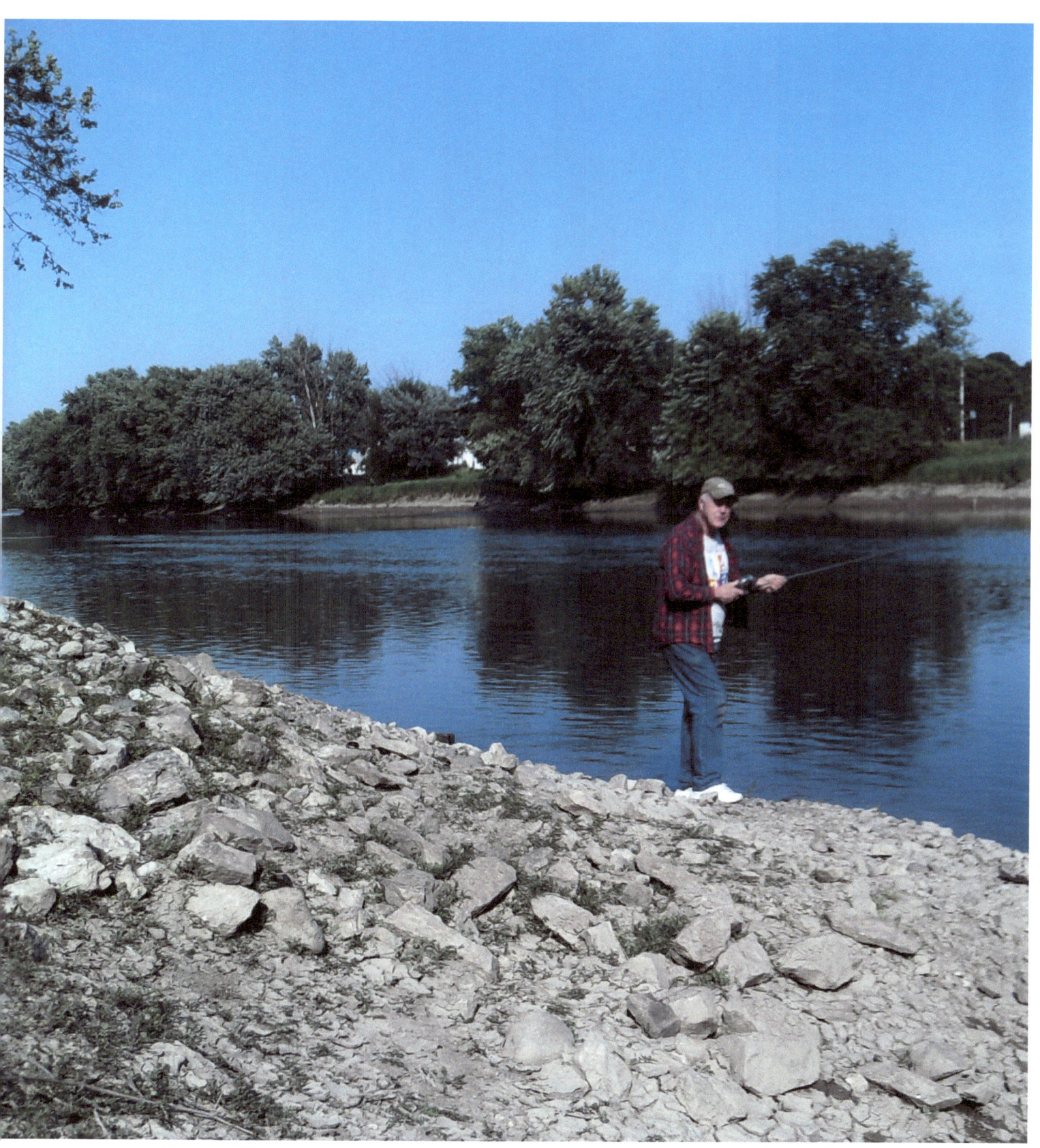

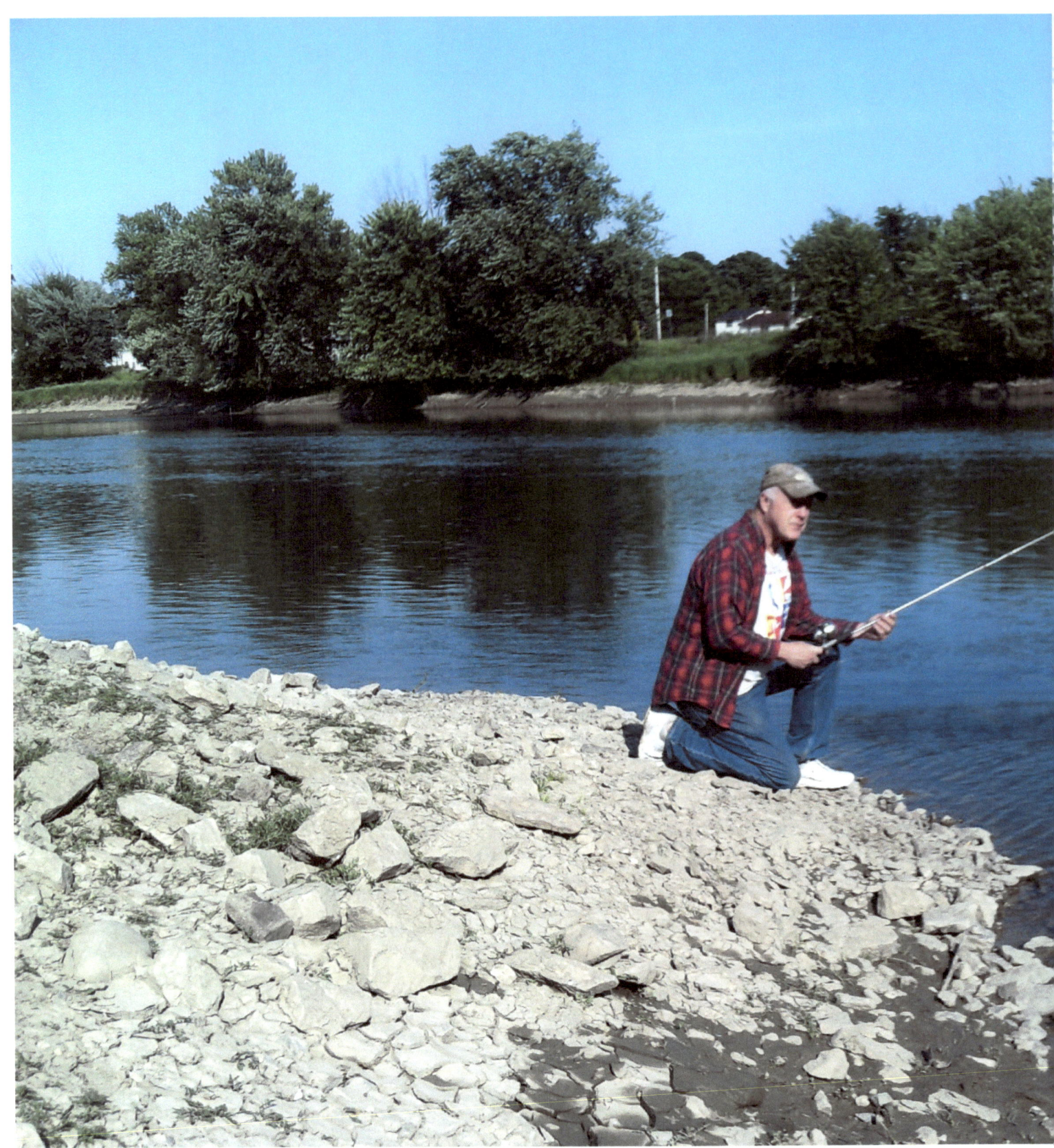

The End

www.ingramcontent.com/pod-product-compliance
Lightning Source LLC
Chambersburg PA
CBHW050839180526
45159CB00004B/1956